Acrylic Painting

WITH JOAN HANSEN AND WILLIAM F. POWELL

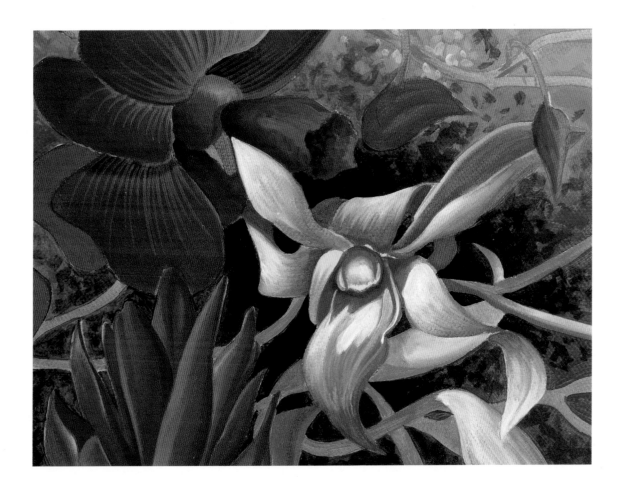

Contents

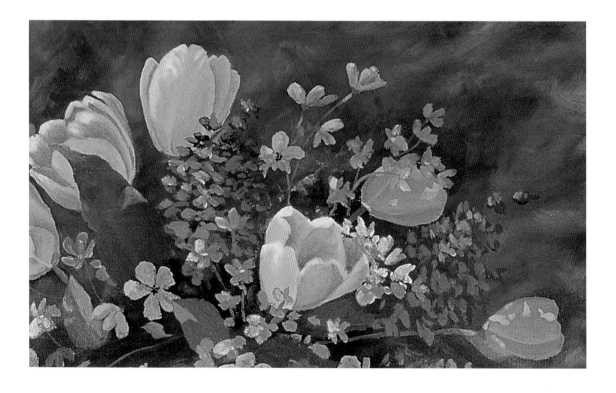

Introduction

*A*crylic is a popular art medium because of its versatility. For beginning painters and accomplished artists alike, acrylic is great for exploring new techniques and expanding creativity. Acrylic—also known as polymer paint—can be applied thickly with rich textures, similar to oil paint, or it can be applied in thin washes or glazes, like watercolor. It can even be used to imitate the precision and minute detail obtainable with egg tempera. Acrylic paint is synthetic (human-made) and can be combined with other media to achieve interesting results. However, when combining acrylic with other media, it is best to find out which paints are compatible and use them accordingly. For example, acrylic makes a suitable underpainting for oil paints because it bonds with the layers of oil applied over it. On the other hand, acrylic cannot be applied over oil because the acrylic will eventually separate from the oil.

The binder in polymer paints is an acrylic resin emulsion that can be thinned with water. When dry, this "plastic" paint is permanent and tough; it cannot be rewetted and restored to its original fluid state. This also means you can paint over your work as much as you want without muddying the colors. Acrylic is also flexible and can be used on virtually any porous surface, including canvas, cloth, illustration board, watercolor paper, and pressed-wood panel. But the paint does not adhere to nonporous surfaces, such as glass, plastic, and porcelain.

Acrylic dries very quickly, which can sometimes frustrate artists who need more time to blend and manipulate the paint. When painting with acrylic, remember to (1) maintain dampness in areas where you want to blend colors, and (2) plan your work in stages. "Extenders" that slow the drying time of acrylic are available at art supply stores. Add these extenders to water or paint and then apply them to the painting surface with a mist sprayer or brush. There are also thickening agents available that allow you to apply acrylic paint the way oil paint is applied in knife painting (see *Oil Painting Techniques* by William F. Powell in Walter Foster's Artist's Library series).

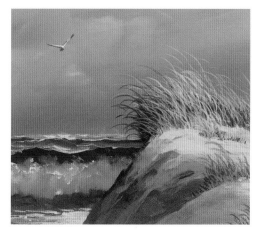

In this book, both artists use a limited palette of six colors (crimson, brilliant red, lemon yellow, burnt sienna, phthalocyanine, or *phthalo*, blue, and white). Reeves offers conveniently packaged sets of acrylic paints that make an excellent choice for artists of all skill levels.

We hope this book will provide you with a solid introduction to acrylic and that you'll continue to explore new techniques with this versatile medium.

Tools and Materials

Acrylic Paint

Acrylic paint comes in several forms, including tubes, jars, and cans. Tube paints are the most popular and convenient type of acrylic paint, and Reeves manufactures several sets of acrylic tube paints that are ideal for beginners. Before beginning the projects in this book, test the suggested colors on a separate sheet of practice paper to familiarize yourself with their characteristics. Try combining them to see what new colors you can mix, and experiment with the various effects you can create. Once you start painting, remember that the viscosity of acrylics requires a thick application (or multiple layers) of paint to achieve intense lights and darks.

Brushes

Round brushes are great for detail work and for achieving a variety of different stroke widths, whereas flats are well-suited for long, soft strokes and blends. Reeves has a selection of paintbrushes that are perfect for the projects in this book. Most acrylic artists prefer synthetic-hair brushes, but you can also use natural-hair brushes. However natural-hair brushes require careful maintenance for long-term use because acrylic paint tends to cling more readily to natural hairs. Make sure you keep your brushes damp while you're painting because acrylic paint dries quickly, and the dried paint can ruin the hairs. At the end of a painting session, make sure you wash your brushes thoroughly with mild soap and cool water. (Caution: Never use hot water. Hot water can cause acrylic paint to set in the brush, making it very difficult to remove.) After you rinse out your brushes, reshape the bristles carefully with your fingers and lay them flat or allow them to dry bristle-side up.

SUPPLIES Since 1766, Reeves has been manufacturing excellent-quality paints and brushes and has long been established around the world as a wonderful source of art material for beginners. Reeves paints and brushes are available at art supply stores everywhere.

Painting Surfaces

Because acrylic is so versatile, you can paint on just about any surface—called a "support"—as long as it is slightly porous and isn't waxy or greasy; water-thinned acrylics won't adhere to oily surfaces. Most acrylic painters use canvas, a fine-surfaced fabric that is available stretched and mounted on a frame or glued to a board. If you like a smoother surface, watercolor paper and primed (sealed) wood panels are good alternatives.

Painting Medium

The only medium you really need for acrylic paints is plain water (although there are many types of mediums available; see page 5). Thin your color mixes with water to create *washes*—thin, transparent coats of paint. Add more water to lighten a color and less water to deepen it. When painting a wash, it's also helpful to apply water to your painting surface with a brush, sponge, or mist sprayer. This will make the paint bleed and create a soft look. If the surface is dry, your strokes and color applications will be more controlled and have harder edges.

Mixing Palette

You can use glass, ceramic, or plastic palettes with acrylic paint. Plastic palettes are convenient; since dry acrylic paint doesn't adhere to nonporous surfaces, you can easily wash them off with water. It's a good idea to purchase a palette that has multiple wells for pooling and mixing colors while painting. And you may want to purchase a palette knife to mix your paints; you can also use it to create dramatic special effects.

Distinguishing Supports

Some supports, such as illustration board and canvas, are paint-ready at the time of purchase. Others, like pressed wood panels, have a porous surface that needs to be primed with a sealer (usually acrylic gesso) first to make it less absorbent. Different surfaces also have different textures—smooth to rough—which affect the appearance of the paint. The examples at left show how thick (left) and thin (right) applications of acrylic paint appear on the different supports.

Primed pressed wood panels (rough side)

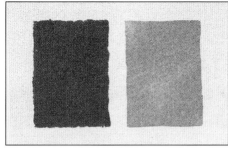

Primed pressed wood panels (smooth side)

Illustration board

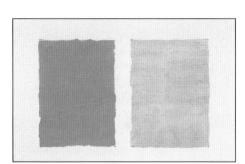

Canvas board

Using Painting Mediums

Because acrylic is water based, you can thin it simply by adding water, and that's all you'll need to do when you're first starting out. Once you've acquired a little more expertise, though, you might want to try mixing the colors with various painting mediums—additives that change the nature of the paint in various ways, such as making it dry slower, appear more transparent, or become thicker. Some also add luster, making the colors look more translucent than with water alone. The samples at left show a few of the most popular painting mediums and how they mix with acrylic paints. Don't be alarmed by the look of the mediums; they start out with a milky white color but they become transparent when dry!

Gloss medium

Matte medium

Gel medium

Texture medium

Retarding medium

Flow improver

WORKING WITH MEDIUMS Adding a medium to your paint changes its characteristics. *Glosses* thin the paint and give it a shiny surface when dry; *matte* mediums dry dull. *Gel* medium allows you to create some texture, as it thickens the paint. *Texture* mediums also thicken; they're used to create sharp ridges and patterns. *Retarders* slow the paint's drying time, and *flow improvers* do just that: help the paint flow easily.

Color Basics

To mix color effectively, it helps to understand a little bit about color theory. There are three *primary* colors (yellow, red, and blue); all other colors are derived from these three. *Secondary* colors (purple, green, and orange) are each a combination of two primaries (for example, mixing red and blue makes purple). *Tertiary* colors are the results you get when you mix a primary with a secondary (red-orange, yellow-orange, yellow-green, blue-green, blue-purple, and red-purple). *Complementary* colors are any two colors directly across from each other on the color wheel. In addition, *hue* means the color itself, such as red or blue; *intensity* refers to the strength of a color, from its pure state (straight from the tube) to one that is grayed or muted; and *value* refers to the relative lightness or darkness of a color or of black.

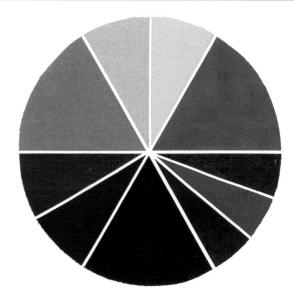

COLOR WHEEL A color wheel is a convenient visual reference for mixing colors. Knowing the fundamentals of how colors relate to and interact with one another will help you create feeling—as well as interest and unity—in your acrylic paintings. You can mix just about every color you would ever want from the three primaries. But all primaries are not created alike, so you'll eventually want to have at least two versions of each primary, one warm (containing more red) and one cool (containing more blue). These two primary sets will give you a wide range of secondary mixes.

Warm and Cool Colors

Generally colors on the red side of the color wheel are considered to be *warm,* while colors on the blue side of the wheel are thought of as *cool.* But within a family of colors, some are warm and others are cool—for example, within the red family, there are warmer orangish reds and cooler bluish reds.

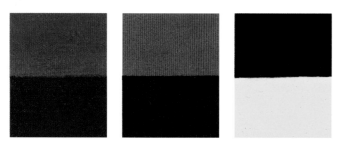

DIRECT COMPLEMENTS Each of these examples is a pair of direct complements. Direct complements create the most striking contrasts when placed next to one another. When you want to create drama or vitality in your paintings, place a color next to its complement.

Complementary Colors

When placed next to each other, complementary colors create visual interest, but when mixed, they neutralize (or "gray") one another. For example, to neutralize a bright red, mix in a touch of its complement: green. By mixing varying amounts of each color, you can create a wide range of neutral grays and browns. (In painting, mixing neutrals is preferable to using them straight from a tube; neutral mixtures provide fresher, realistic colors that are more like those found in nature.)

Value

The variations in value (the relative lightness and darkness of colors) throughout a painting are the key to creating the illusion of depth and form. On the color wheel, yellow has the lightest value and purple has the darkest value. You can change the value of any color by adding white or black to it. Adding white to a pure color results in a lighter value *tint* of that color, adding black results in a darker value *shade* of that color, and adding gray results in a *tone.* (A painting done with tints, shades, and tones of only one color is called a *monochromatic* painting.) In a painting, the very lightest values are the *highlights* and the very darkest values are the *shadows.*

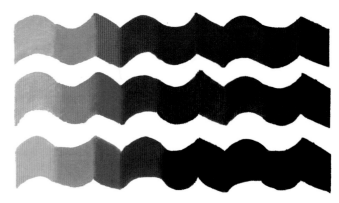

TINTS AND SHADES This diagram shows varying tints and shades of three different colors. The pure color is in the middle of each example; the tints are to the left and the shades are to the right.

Mixing Color

Learning to mix colors is a learned skill, and, like anything else, the more you practice, the more skilled you will become. You need to train your eye to really see the shapes of color in an object—the varying hues, values, tints, tones, and shades of the object. Once you can see them, you can practice mixing them. At right are three neutral gray mixtures created with three different blues mixed with orange and white. Notice that each mix results in a different gray, depending on whether the blue is warmer (such as brilliant blue) or cooler (such as phthalo blue). Learning to see subtle differences in color (as in these examples) is essential for successful color mixing.

brilliant blue, cadmium orange, and white

ultramarine blue, cadmium orange, and white

phthalo blue, cadmium orange, and white

Color Creates Mood

Color has a tremendous effect on our feelings and emotions, so color is used to evoke certain moods in paintings. For example, a painting done with mostly dark, muted colors may be viewed as dramatic or ominous, while a painting composed of light, bright colors may be thought of as happy and cheerful. Paintings done with bright, pure colors can be very bold and eye-catching or even loud and unsettling. Your choice of colors will determine whether your paintings appear warm and comfortable, cool and refreshing, or vibrant and dramatic. Keep this in mind as you develop your color palette.

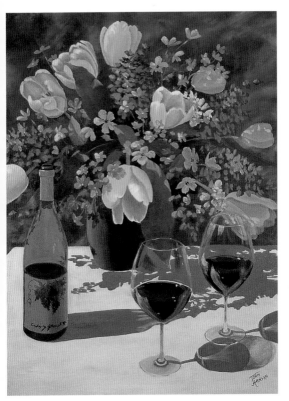 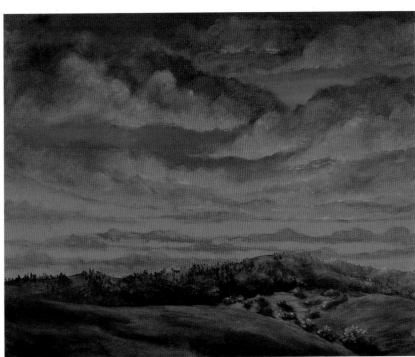

CONTRASTING MOODS Compare the moods of these two paintings. The warm yellow tulips and bright blue background in the still life on the left convey a cheerful feeling, while the bold contrast of the red clouds set against the dark green hills in the landscape on the right create a more dramatic, striking effect.

Getting to Know the Paint

Brushwork

Your brushstrokes are just as important as the colors you choose for a painting. Many artists feel that their brushwork is just as distinctive as their handwriting. The brushes you use play a big part in how your brushstrokes look; a round brush leaves a different print than a flat one does, and the size of the brush affects its imprint. The way you hold a brush and the amount of pressure you apply will also change the appearance of your strokes. You can create thin lines with the edge of any brush, make bold strokes by applying more pressure, and taper your strokes by lessening the pressure and lifting up at the end. Practice the techniques demonstrated on these pages on a separate sheet of paper (cold-pressed watercolor paper works well) or a canvas sheet to see what effects you can produce. Have fun experimenting with color mixtures and drying times; you'll soon come to your own conclusions that will contribute to your creation of beautiful acrylic paintings and your own unique painting style!

DRYBRUSHING Drybrushing is great for creating texture in paintings. First paint an even layer of color and let it dry. Then load your brush with a new color, remove excess paint with a paper towel, and stroke lightly over the first layer, allowing the underlying color to show through.

CHANGING DIRECTION You can create a variety of widths with your flat brush by keeping your bristles at the same angle but stroking the brush in different directions. Practice with different brushes and angles to familiarize yourself with the different effects you can achieve.

BLENDING To create soft blends, use a soft, flat brush and gentle brushstrokes. Paint even, overlapping layers, varying the direction of your strokes to evenly blend the colors and hide your brushstrokes.

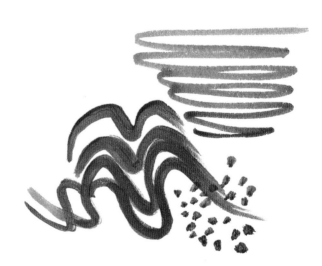

DRAWING WITH THE BRUSH Use the tip of your round brush to render simple lines and dots with precision. For maximum control and precise strokes, be sure to remove excess paint from the brush before drawing.

Washes

A wash is a layer of color thinned with water so that it is transparent and flows easily. You can make the color lighter or deeper depending on how much water or flow improver you add. Keep in mind that washes flow better when applied to a dampened surface, as this gives you more time before the paint dries. Many acrylic painters like to begin their paintings by toning the entire support with a wash and then building up the tones of the painting by adding transparent layers over the initial wash, or *underpainting*.

FLAT WASH A flat wash is an easy way to cover a large area with a solid color. Load a flat brush with diluted paint, and—holding your support at an angle—sweep the color evenly across in successive strokes. Add more paint to your brush between strokes, and let the strokes blend together.

Exploring Techniques

You can use acrylic paint straight from the tube or dilute it with water to produce an array of different effects—from thick *impasto* applications to transparent washes. Another popular acrylic technique is painting *wet-into-wet,* or brushing fresh paint over a still-wet layer of paint and allowing the colors to blend. The samples below and on the following pages show just a few of the many exciting effects you can achieve with acrylic by varying brushstroke, color, and technique.

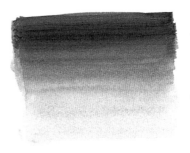

GRADED WASH A graded wash graduates from dark to light, which makes it a perfect technique for depicting water and skies. Use a flat brush and paint horizontal strokes across a tilted surface, just as you would for a flat wash, but add more water to each subsequent stroke to gradually lighten the color.

THICK STROKES To create texture and variation in your paintings, apply thick paint with a large brush, creating small peaks with the paint. This is called "impasto." Many acrylic artists use impasto to call attention to a specific area of a painting, as thicker paint has more of a noticeable presence on a support.

THICK BLENDS You can achieve interesting effects by mixing thick acrylic paint directly on your support with a flat, wet brush. For example, in the demonstration above, blue and yellow gradually blend to form green, creating a soft, loose blend. This type of gradual blend is great for painting subjects in nature.

THICK ON THIN Another way to texturize your acrylic paintings is to add a thick layer of paint over a thin layer. First apply a thin, transparent wash to establish your "ground," or base color. Then paint thickly on top, leaving gaps to let some of the underlying color show through, which creates the illusion of depth and texture.

DRY ON WET To create a grainy texture, pull a dry brush with very little paint over damp paper. This will make the colors separate, leaving spots of white paper, and will make the strokes of the individual bristles visible in your brushstrokes. This technique is especially useful for depicting rough textures like wood grains, bark, and stone.

Special Techniques and Effects

STRAIGHT LINES Place the metal *ferrule*—the band below the bristles of the brush—against a straightedge and pull along the edge sideways. To make jagged, crooked lines, start and stop as you pull. Use straight lines when painting human-made structures, such as buildings, fences, and tables.

SPONGING You can create an interesting effect by dabbing a kitchen sponge in paint and lightly patting it on the painting surface. For pattern variation, use different colors of paint and turn the sponge as you dab. Sponging is great for painting foliage, or—if done with white paint and light, soft dabs—for puffy clouds.

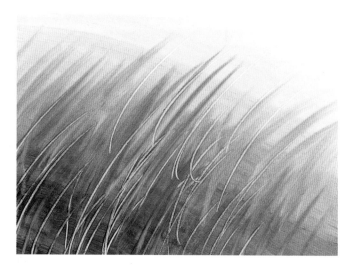

SCRATCH STROKES To scratch out color as shown above, first wet the surface with water. Brush on a thin wash of yellow; then do the same with brown. While the washes are wet, use the end of the brush handle to scratch out diagonal lines. This technique is suited for painting fine lines for grasses (see page 11), fur, and hair.

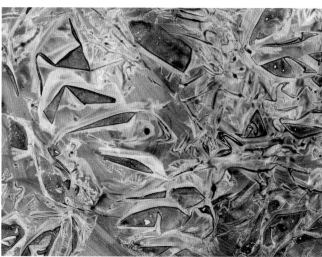

CREATING TEXTURE WITH PLASTIC For this unusual effect, wet the surface, and apply a dark wash of burnt sienna and phthalo blue. While still wet, press crinkled plastic wrap into the paint. Remove the plastic when dry. Use this technique to create background textures and to depict water.

KNIFE PAINTING Practice painting with a palette knife, using the flat blade to spread a thick layer of paint over the surface. Each knife stroke creates thick ridges and lines where it ends, mimicking rough, complex textures like stone walls or rocky landscapes. You can also use the edge of the blade and work quickly to create thin linear ridges that suggest and define shapes. Even the point of the knife is useful; use it to scrape away paint to reveal whatever lies beneath.

Creating Skies

CLEAR SKY Create this effect with a blue wash along the top left merged with a mix of brown on the right. Add more water toward the bottom (a graded wash) to make the color appear weaker.

STORMY SKY Paint this simple sky by wetting the surface with clear water and then pulling several strokes of color across it. Use blue, brown, and white, and allow the water to create soft blends.

Painting Grass

Suggesting Foliage

STEP ONE Wet your painting surface and apply a wash of yellow to the top. Quickly add a wash of brown in the center. Then wash in a mixture of brown and blue along the bottom.

STEP TWO While the colors are still wet, use the edge of a flat brush and make vertical, sweeping strokes to indicate blurred blades of grass. These less distinct blades will appear to recede.

DISTANT FOLIAGE Paint dark strokes with a round brush on a dry surface. Dab at the surface with short, quick movements, layering the colors over one another.

STEP THREE Use the end of the brush handle or a toothpick to scrape out lighter grass blades. Letting the undercolor show through the subsequent layers of paint adds interest and texture.

STEP FOUR Mix brown with a little blue. Use the round brush and stroke upward, lifting up at the end of each stroke to create a tapered end. The light and dark grasses create the illusion of depth.

FOREGROUND FOLIAGE Use a flat brush and layer dark colors with short, single strokes. To lighten the background layer of foliage and create depth and distance, dilute the paint with water.

Lesson 1: Floral

by William F. Powell

This vibrant painting shows a closeup of orchids and ginger. Notice how tightly the subject is cropped and that there is very little detail in the background of the painting. Don't be afraid to "zoom in" on your subjects like this. A tight frame can make a painting interesting and is an excellent way to pull the focus entirely onto your subject.

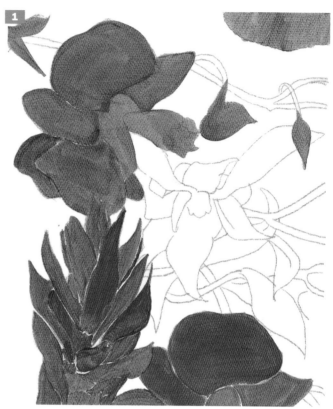

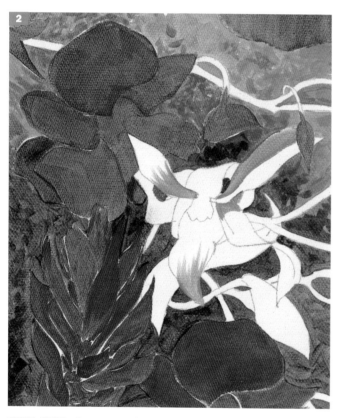

STEP ONE Begin by drawing flowers in any arrangement you like. You don't have to paint all these flowers; just select one or two and design your own composition. Make sure the composition shows balance and is pleasing to the eye. Once you've drawn the arrangement to your satisfaction, wash in a base color of crimson on the orchids and brilliant red on the ginger. Add a speck of phthalo blue to create a blue-purple mixture. Your brushstrokes should follow the shape of each petal.

STEP TWO Continue washing in the undercolors of the petals, focusing on the direction of the brushstrokes. Add white to the blue-purple mix for the center orchid. For the background, mix a variety of greens using phthalo blue, lemon yellow, and burnt sienna. For lighter greens, add more lemon yellow and white. The greens should vary in value and richness throughout the background.

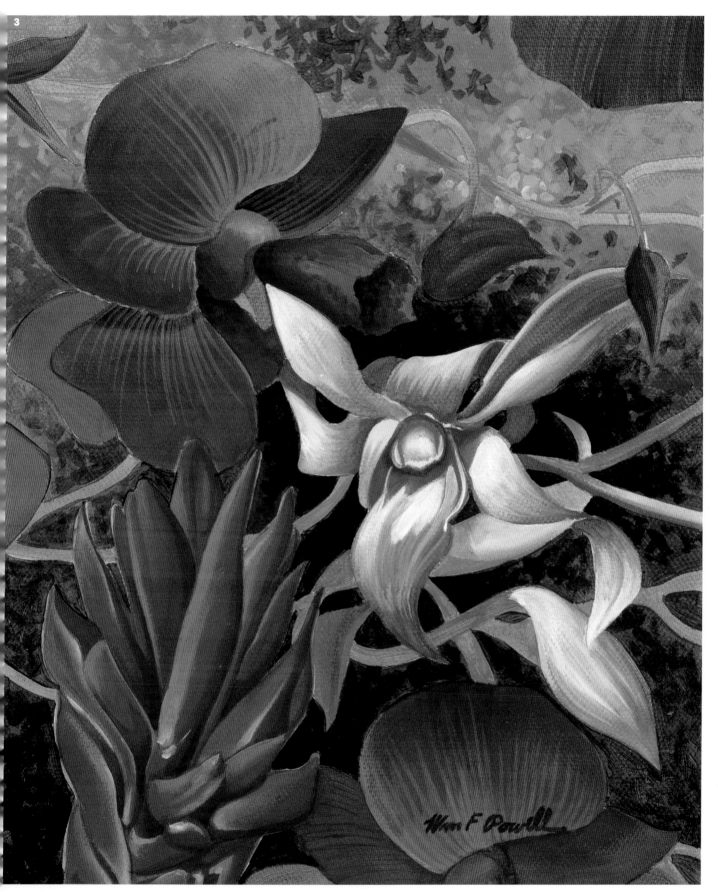

STEP THREE Next build up layers of both light and dark colors, making your first dark layer somewhat transparent. To develop depth, texture, and detail with color, paint overlapping layers, alternating between light and dark paint. The lightest areas tend to fade in brilliance, so be sure to apply a number of layers of color. Allow the paint to dry between layers, and each application will enhance the next. The contrasting values and complementary colors will also help the flowers to "pop" off the background. The dark greens in the background are developed by painting numerous layers over one another. To create the illusion of foliage, use very short strokes, continuously changing the direction of your brush.

Lesson 2: Seascape

by William F. Powell

Acrylic paint dries rapidly, so plan out your composition and work quickly. When creating blends, it's best to work on one small area at a time to keep the paint wet and workable. If the colors begin to set, either spray the surface with water or apply more fresh paint.

Water and Foam

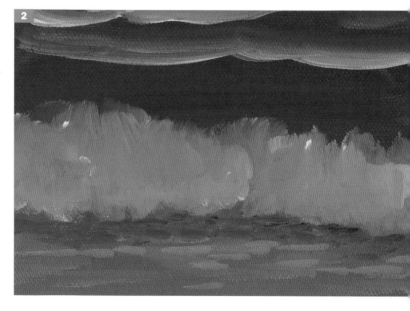

white + yellow

burnt sienna + phthalo blue

Add white for center colors

white + red and yellow + bit of center color

Add more phthalo blue and a bit of white to the mix above

+ more white

white + yellow + center mix

COLOR MIXTURES The colors above are small "smearings" of the basic mixtures used in this painting. Notice how they affect one another where they are intermixed. Here white was used as a lightening agent to tint the colors. Adding white also makes colors more opaque. Use very little water in these mixtures to keep the colors fresh and lively.

STEP ONE Use a flat brush to paint a deep blue-green underpainting of burnt sienna mixed with a little phthalo blue near the top of the water area. Paint horizontal strokes across the surface, adding white and more burnt sienna as you work downward. When you reach the bottom, add more white mixed with a tiny amount of lemon yellow.

STEP TWO While the underpainting is still damp, load a flat brush with white, and paint wavy lines across the water without lifting the brush from the surface. Beginning on the right side of the foam area, stroke up and down while working to the left. Then rewet the water area, and draw the wave formations in white with the edge of the flat brush. While the water area is still wet, paint the main area of foam with the blue-green color from step one mixed with some white.

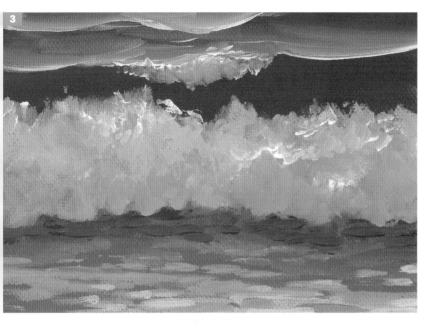

STEP THREE Once you've developed the main shape of the foam, add dabs of white here and there for light accents. Add light blue (a mix of phthalo blue and white) to the lower edge of the foam to accent the colors and add depth. Then create the illusion of sand and water ripples using various mixtures of white, lemon yellow, and a small amount of brilliant red. Load the brush with a lot of paint, and be sure not to blend these strokes so the texture of the water is retained.

Sky and Clouds

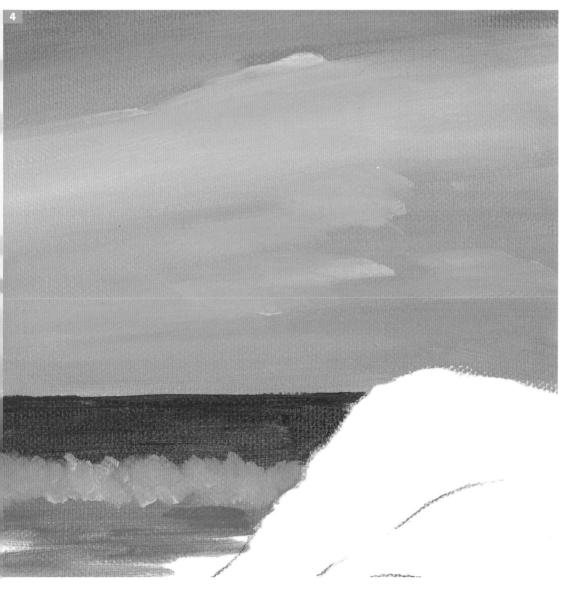

STEP FOUR The sky is a combination of the central color mixes shown on page 14. Use mixtures of these colors, and paint them in long, sweeping strokes. Then, while the sky is still wet, use the white and light yellow mix from step three to paint the clouds. If the area dries before you've finished the clouds, rewet it with a thin wash, or *glaze,* of the same color.

Sand Dunes

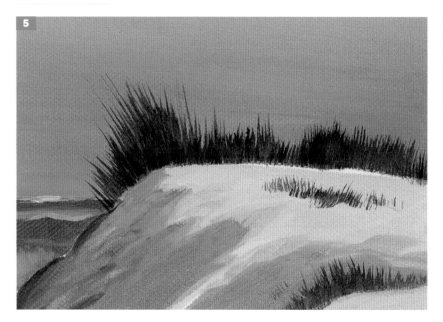

STEP FIVE Paint the shape of the dunes with a mixture of white, lemon yellow, and a touch of brilliant red. Use only a tiny bit of red in your mix for the sunlit sand. For the shadows, add burnt sienna, phthalo blue, and a little more brilliant red. Apply the undercolor of the grass shapes with burnt sienna. Lift your brush at the end of each stroke to create pointed blades of grass.

STEP SIX Create a green mixture with lemon yellow and touches of phthalo blue and burnt sienna. Use the tip of a round brush to paint grass strokes over the dry, dark undercolor. Curve the strokes so the grass looks as if it is blowing in the wind.

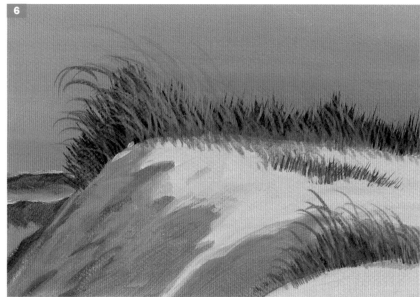

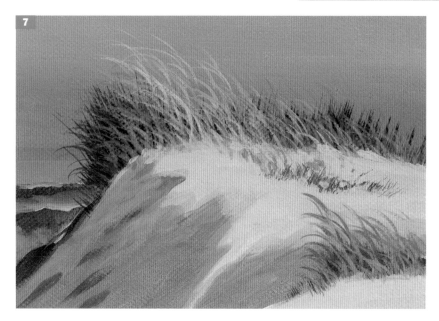

STEP SEVEN For the grass highlights, add lemon yellow and a bit of white to the green mixture. (Be sure not to use too much white.) Make some of your final, lighter grass strokes finer than the previous grasses underneath this layer. This will make this grass appear thicker.

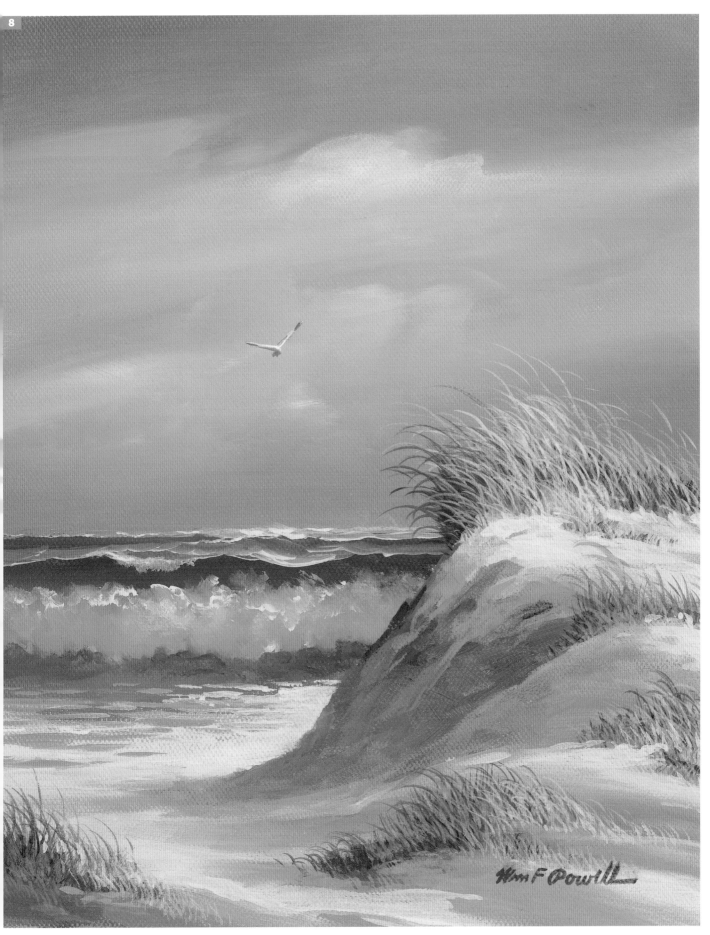

STEP EIGHT Once the grass is in place, go back and add light sand colors between some of the blades to create depth. Add a few more highlights to the dunes and the clouds. Finally add the sea gull in the sky, defining its wing tips with burnt sienna to set it off from the white clouds.

Lesson 3: Doorway

by Joan Hansen

This scene of a Tuscany villa viewed through a doorway provides an interesting study in perspective. Here (as in all compositions) the objects in the distance are much less detailed and should be more loosely rendered than the objects closest to the viewer. The objects that are closest to the viewer, such as the stones in the foreground, should be depicted with the greatest attention to form and detail. Remembering to follow these simple rules of perspective will help you develop the correct depth and dimension in all your paintings.

STEP ONE Sketch the basic shape of the door frame, using a ruler or a T square to make your lines straight. To retain the straight lines, tape off the door casing with masking tape or artist's tape.

WALL

| lemon yellow + white | brilliant red + white + lemon yellow | white + crimson |

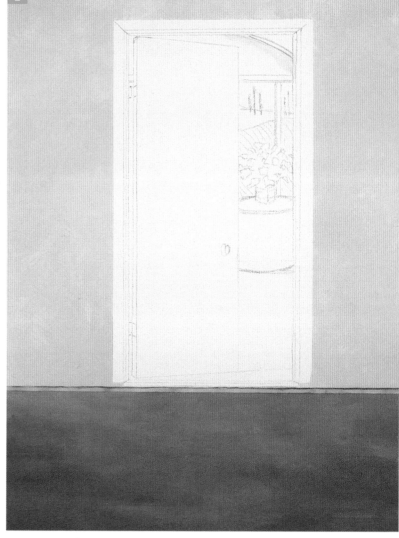

STEP TWO To create the textured look of the wall, overlap the various light values shown at left, starting with the yellow tint and adding peach and then pink. For the area just above the walkway, use deeper values of the same colors. Remove the masking tape before the paint dries, and clean up the edges with a clean, damp flat brush. Block in the stone walkway with three gray values: (1) white with a little phthalo blue and burnt sienna, (2) equal amounts of white and burnt sienna with a touch of phthalo blue, and (3) purple (phthalo blue and crimson) mixed with white and a little burnt sienna.

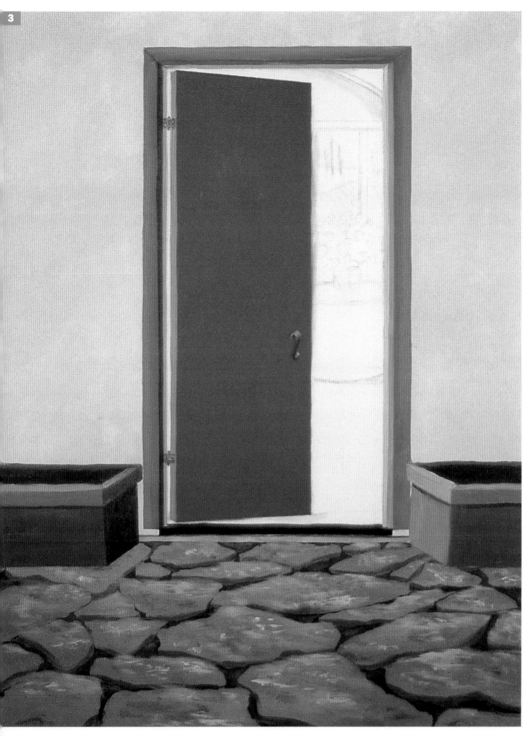

**Mix 1:
phthalo blue + white
+ touch of crimson**

**Mix 2:
mix 1 + white**

**Mix 3:
mix 2 + white**

STEP THREE After the walkway dries, draw the outlines of the stones. Then paint the edges of the stones with deeper versions of the gray mixtures from step one, adding a dark green tone between the stones with a round brush. To add texture, use a technique called "scumbling" (lightly rubbing a brush with only a little paint on it over an underlying layer). Scumble the warm, light colors from the wall over the gray stones with a flat brush to render some textured highlights. Next mix three shades of blue for the door and flower boxes. Begin with the darkest—a mixture of phthalo blue with a little white, crimson, and some burnt sienna—and apply it over the darkest shadow areas; then use this mixture as the base to create a medium blue by adding more white. Use the same mix to indicate highlights on the left side of the right flower box and around the rim of the left flower box. Next mix the lightest value by adding even more white to the medium blue mixture. With this light mix, line the inside of the door frame and the rim of the right flower box.

STEP FOUR Now mix a variety of greens as shown below, and block in the bougainvillaea and the potted flowers with the darkest value. Then build volume in the foliage by gradually lightening your mixtures with white and layering them on your support. For the purple geraniums, mix three values of purple, starting with a base of crimson and a touch of phthalo blue. Add a little white for a medium value and more for a lighter value. Use the three mixes to paint the geraniums in the flower boxes. For the bougainvillaea, mix three values of crimson, brilliant red, and white. Paint the darkest values of the flowers first, applying the paint with several dabs of color.

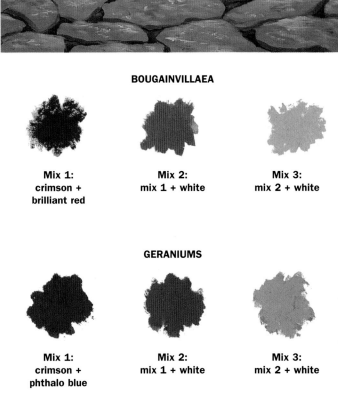

FOLIAGE

Mix 1:
phthalo blue
+ lemon yellow
+ touch of white

Mix 2:
mix 1 + white

Mix 3:
mix 2 + white

Mix 4:
mix 2 + burnt
sienna

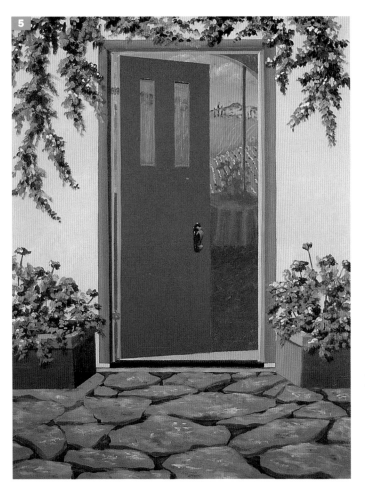

BOUGAINVILLAEA

Mix 1:
crimson +
brilliant red

Mix 2:
mix 1 + white

Mix 3:
mix 2 + white

GERANIUMS

Mix 1:
crimson +
phthalo blue

Mix 2:
mix 1 + white

Mix 3:
mix 2 + white

STEP FIVE Paint the background landscape, distant hills, and vineyard with the lighter mixes of green from step one. Use the medium blue mix from step three for the sky, and add a touch of phthalo blue to white to create the wispy clouds. Paint the silhouetted interior with three shades of gray mixed from phthalo blue and burnt sienna, with varying amounts of white. Create warmer values to indicate light shining through the doorway by adding a touch of lemon yellow. For the darkest areas, mix cooler, deeper values by adding more blue.

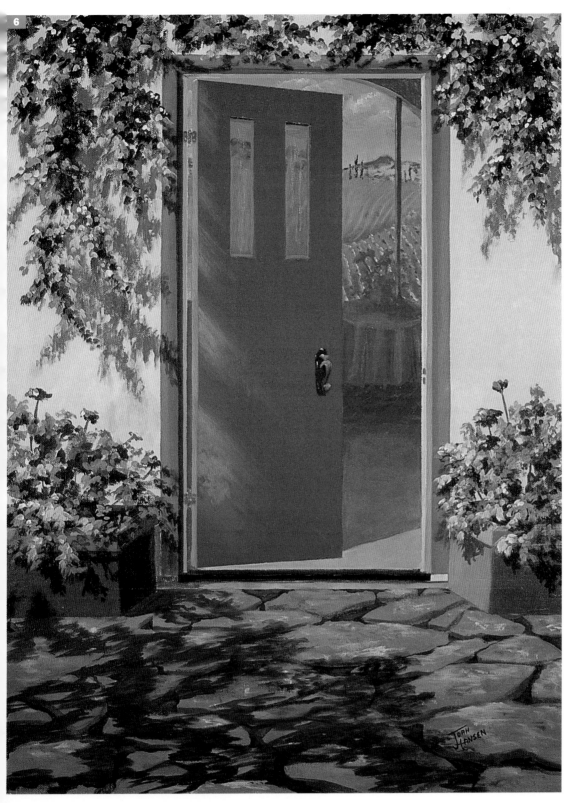

STEP SIX Now paint the cast shadows with grayed purples and blues. For the gray-purple of the shadows on the stone walkway, mix phthalo blue, burnt sienna, crimson, and a little white. For the darkest shadows, add more crimson to this mixture. To create the gray-blue of the shadows on the flower boxes and door frame, darken mix 3 from page 19. Many of the shadows are cast by the geraniums and bougainvillaea, so use soft brushstrokes to create the illusion of sunlight being filtered through the foliage. To intensify the impression of streaming sunlight, create a light blue mixture with phthalo blue and white, and add some beams of sunlight on the open door. Finally paint the door handle with a mixture of burnt sienna and a little phthalo blue, and add highlights on the handle with a touch of burnt sienna mixed with yellow.

Lesson 4: Landscape

by Joan Hansen

Painting dramatic skies is a fun way to experiment with using a variety of colors and shapes. The most opportune times to capture brilliant colors are at dawn and dusk, when the light is soft and low, and the sky is often filled with color. This painting captures the bright glow of the sky just as the sun is setting.

STEP ONE Block in the upper sky with a large flat brush and a mixture of phthalo blue, crimson, and a little titanium white. To paint the middle of the sky, add more crimson and white to the mixture, and blend the colors of the upper and middle sky with horizontal strokes. To create the lower areas of the sky, lighten the mixture again with brilliant red and white. Add more of the pink mixture as you work downward to the horizon. For the lightest areas of the sky just above the horizon line, add brilliant red, lemon yellow, and white to the blend, and save some of this light value for later. Now mix five shades of green for blocking in the land mass (see page 25 for color mixtures). Begin with the dark blue-green of the left distant mountain—a combination of phthalo blue, burnt sienna, and lemon yellow. For the mountain on the right, create a gray-green mixture by adding some white to the dark mountain mixture. Add lemon yellow to the previous mixture to create the large foreground hill on the left. Then lighten the mix for the hill on the right with white. Paint the valley in the center by adding some of the light orange mix from the sky to the light green mix.

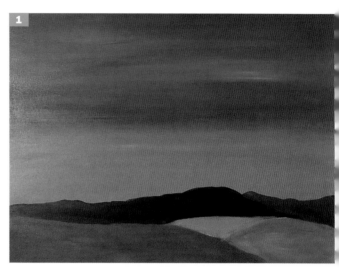

UPPER SKY	MIDDLE SKY	LOWER-MIDDLE SKY	LOWER SKY
phthalo blue + crimson + a little white	upper sky mix + crimson + white	middle sky mix + brilliant red + white	brilliant red + lemon yellow + white

DARK BLUE CLOUDS	MAUVE CLOUDS	LIGHT MAUVE CLOUDS	PINK CLOUDS
phthalo blue + crimson + a touch of white	dark blue cloud mix + crimson	mauve cloud mix + white	crimson + white

STEP TWO Paint the clouds, blocking in the darkest shapes at the top of the composition with dark blue (see the mix above). After this layer is dry, use the mixtures shown above to scumble (see page 19) mauve, light mauve, peach (see page 23), and pink into the clouds using the side of a flat brush. Blot your brush on a paper towel occasionally so you don't apply too much paint; you want the underlying colors to show through.

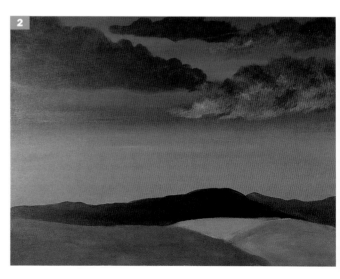

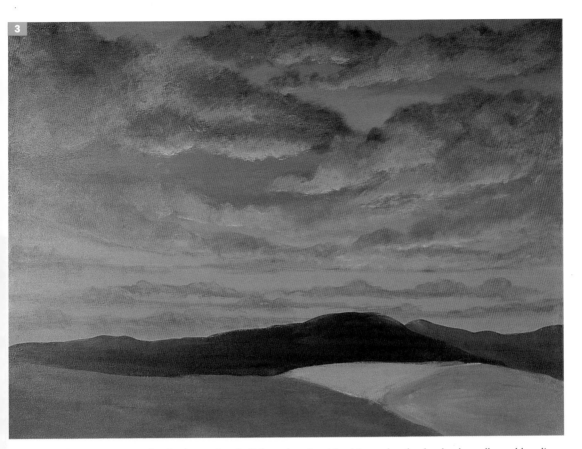

STEP THREE As you paint the clouds, continually lighten the mix with white, and make the clouds smaller and less distinct where they near the horizon. Block in the smaller clouds near the horizon with the mauve mixture, highlighting the bottom of the lower clouds with pink and mauve. Add a touch of yellow to the bottoms of some of the clouds nearest the sun.

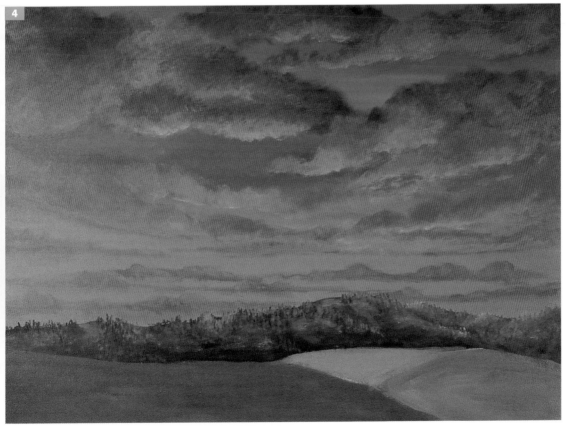

STEP FOUR Now add some details to the scene by indicating trees on the distant hillsides with a small round brush and light, dry brushstrokes. Start with a mixture of phthalo blue, crimson, white, and a touch of burnt sienna. Modify the mixture by lightening it (with white) and slightly graying it (with burnt sienna) to give your foliage some variation. Stagger the placement of the trees along the hilltops to make the skyline more interesting.

HILLSIDE HIGHLIGHTS

Mix 1:
burnt sienna +
crimson + lemon
yellow + a little white

Mix 2:
mix 1 + white

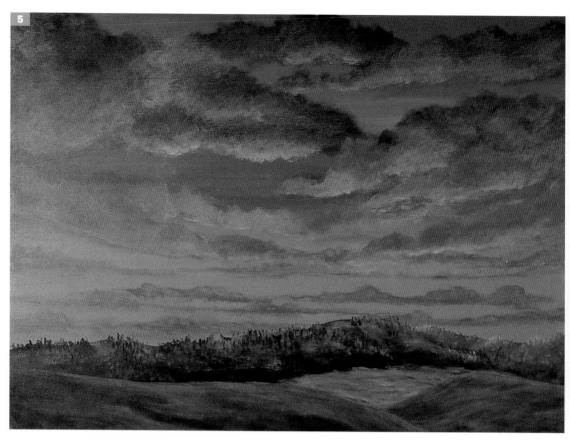

STEP FIVE Once the trees are dry, add some highlights to the landscape. Mix a golden tone for the sunlit portion of the foreground hills with burnt sienna, crimson, lemon yellow, and a touch of white. To make the highlights look natural, add some additional blues and greens from your palette to the foreground hills, scrubbing the paint onto the surface so it blends with the underlying color.

STEP SIX Add more lemon yellow to mix 1 (shown above) to make the foreground hills even warmer toward the center of the scene. Keep the lower portions of these hills relatively dark to emphasize their sunny crests and to create a striking contrast among the greens throughout the painting. Then scrub some browns, blues, and greens over the upper portion of the hills. Add a few green bushes in the foreground and middle ground. Then highlight the foliage with lighter greens.

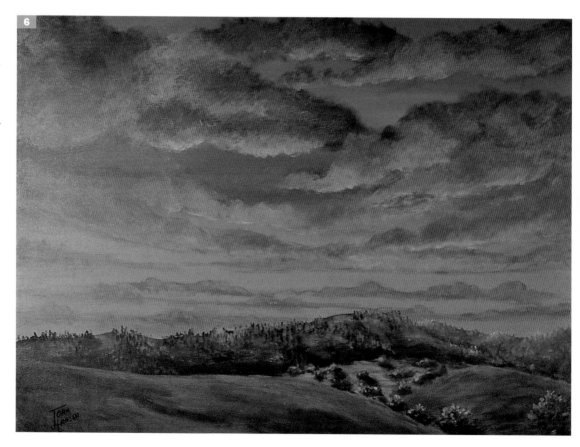

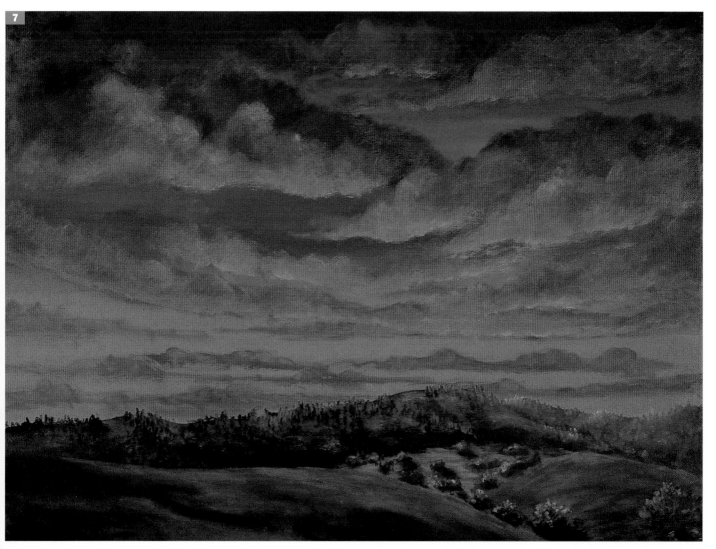

STEP SEVEN Now step back and evaluate the painting; you may want to adjust the structures of some of the clouds to make them stand out even more. For example, the upper left cloud can be made even more striking with a little reshaping. You can also make this sunset more dramatic by deepening the sky with darker values on top of the highest clouds, as shown.

DARK MOUNTAIN	DISTANT MOUNTAIN	LEFT FOREGROUND HILL	RIGHT FOREGROUND HILL	VALLEY
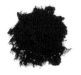				
phthalo blue + burnt sienna + lemon yellow	dark mountain mix + white	distant mountain mix + lemon yellow	left foreground hill mix + white	right foreground hill mix + lower sky mixture (see page 22)

Lesson 5: Still Life

by Joan Hansen

Feel free to use *artistic license* (artists' prerogative to change a scene and paint what they want instead of what's actually there) to alter any details of your reference photos. You can also change or add any colors you wish in order to enhance the painting. Many artists often simplify the backgrounds behind their subjects to ensure that the extraneous details don't detract from their subjects.

BACKGROUND

| phthalo blue + white | phthalo blue + crimson + a little white | crimson + phthalo blue + a touch of white | phthalo blue + lemon yellow + white |

USING ARTISTIC LICENSE In this painting of tulips and wine, artist Joan Hansen emphasizes her focal point by simplifying the background and making the table smaller, moving it to the lower third of the composition.

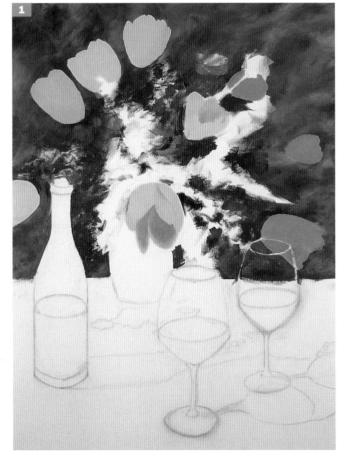

STEP ONE Sketch the scene on your painting surface. Then, starting with the background, apply mixtures of mauve, purple, blue, and green (above left) around the flowers, as shown. Let the background overlap into the edges of the filler flowers; this will allow you to create a clean edge with the floral colors after the background is dry. Next block in the tulips with the three values of yellow shown below. Use the lightest value to block in the flowers that are in full sunlight at the upper left, use the middle value for the flowers in the center, and use the darkest value to paint the tulips that are mostly in shadow on the right.

TULIPS

| white + a touch of lemon yellow | lemon yellow + a touch of white + a touch of burnt sienna | lemon yellow + burnt sienna |

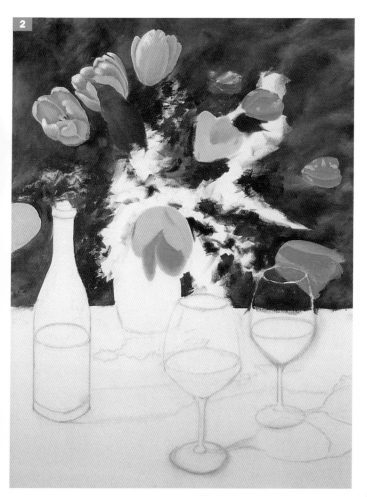

STEP TWO Now develop the individual petals and the structure of the flowers with the three yellow mixtures as shown. If you need a darker value for small crevices, simply add more burnt sienna to the dark yellow mix. To build up the colors of the flowers, use a glazing technique, which is a great way to increase the brilliance of an element in a painting. For the flowers, glaze (see page 15) pure yellow over the warmest areas and pure titanium white over the lightest areas. Begin painting the leaves with the three green mixtures of lemon yellow, phthalo blue, and white shown below.

LEAVES

Mix 1:
lemon yellow +
phthalo blue + white

Mix 2:
mix 1 + phthalo blue
+ a little burnt sienna

Mix 3:
mix 2 + phthalo blue

BLUE FLOWERS

Mix 1:
white + phthalo blue
+ a little burnt sienna

Mix 2:
mix 1 + phthalo blue
+ burnt sienna

Mix 3:
mix 2 + phthalo blue
+ burnt sienna

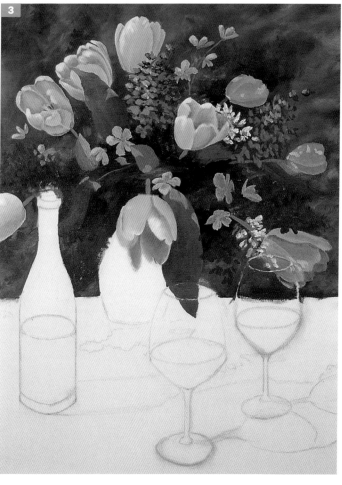

STEP THREE Block in the center of the floral composition with darker values of the blue background colors. Keep in mind that it's easier to paint flowers over a background than to paint a background around tiny flowers. Begin painting the puffy blue filler flowers with a mix of burnt sienna, phthalo blue, and a little white. Apply the darkest values first, continually lightening the blue mixture with white as you work. The mix should be almost completely white for the highlights on the sunlit left side of the flowers. Then paint the rest of the leaves.

Lavender Flowers

Mix 1:
white + crimson
+ a little phthalo blue

Mix 2:
mix 1 + crimson
+ phthalo blue

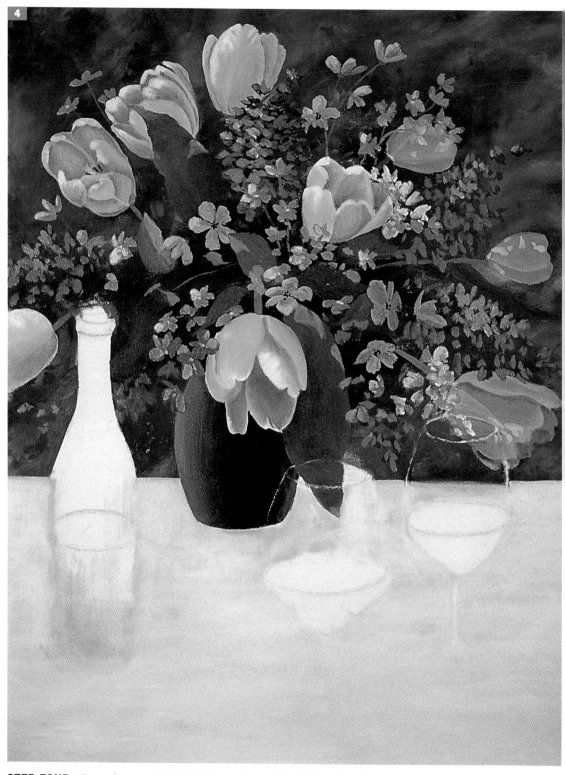

STEP FOUR Create the vase with phthalo blue, and highlight the left side with light blue (a mix of phthalo blue and white). Then wash in the tablecloth with a light beige mixture of white, brilliant red, and burnt sienna, painting into the edges of the bottle and glasses. If you are concerned about losing your drawing, just paint around the objects as close to the line as possible. Paint the lavender flowers with a mixture of crimson, phthalo blue, and a little white, lightening the mixture to add highlights (see color samples above).

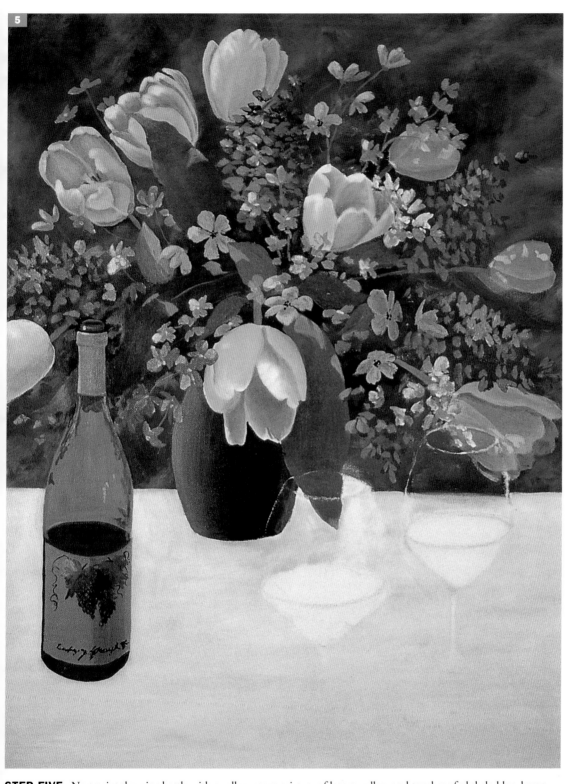

WINE BOTTLE

Mix 1:
lemon yellow + a touch
of phthalo blue + burnt
sienna + brilliant red

Mix 2:
mix 1 + burnt sienna
+ phthalo blue

Mix 3:
mix 2 + burnt sienna
+ phthalo blue

WINE BOTTLE LABEL

Mix 1:
white + brilliant red
+ burnt sienna

Mix 2:
mix 1 + burnt sienna
+ brilliant red

Mix 3:
mix 2 + burnt sienna
+ brilliant red

STEP FIVE Next paint the wine bottle with a yellow-green mixture of lemon yellow and touches of phthalo blue, burnt sienna, and brilliant red. Create the label with three different shades of beige mixed from white, red, and burnt sienna. Pay careful attention to the label—follow the curved shape of the bottle, blending the three shades of beige together as you work. Add the wine with crimson, adding phthalo blue to make the darker areas. Then paint the grapes on the label with a combination of purples and greens from your palette.

29

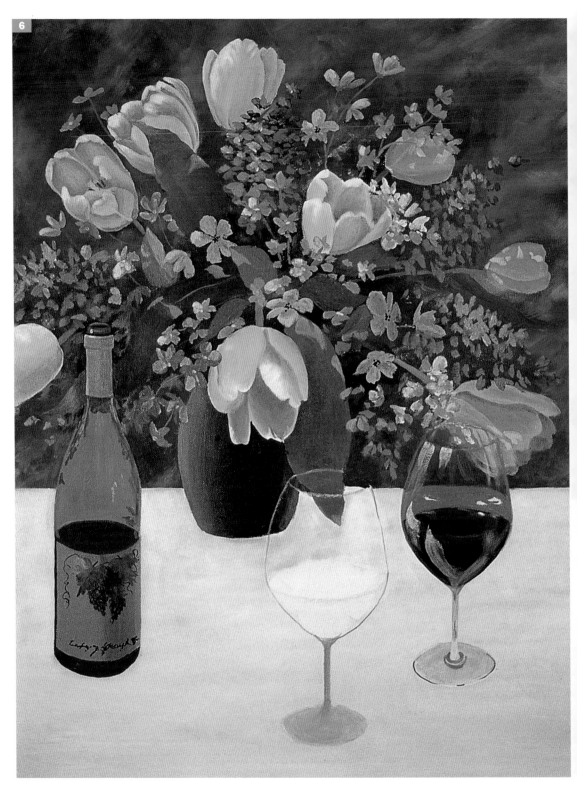

STEP SIX The wine glasses are transparent, so they reflect the colors surrounding them. First outline them with a light blue mix of phthalo blue and white to create their basic shapes. Use the crimson mixtures shown on page 26 to paint the wine in the glass, and develop the stems and the bases of the glasses with light blue. Then lighten the blue mixture with a generous amount of white, and use this mixture to add highlights to the glasses. To make the glass appear realistic, paint the highlights so that they follow the shape and form of the glasses. As a finishing touch to the glasses, carefully paint the rim of each with a small amount of the light blue mixture.

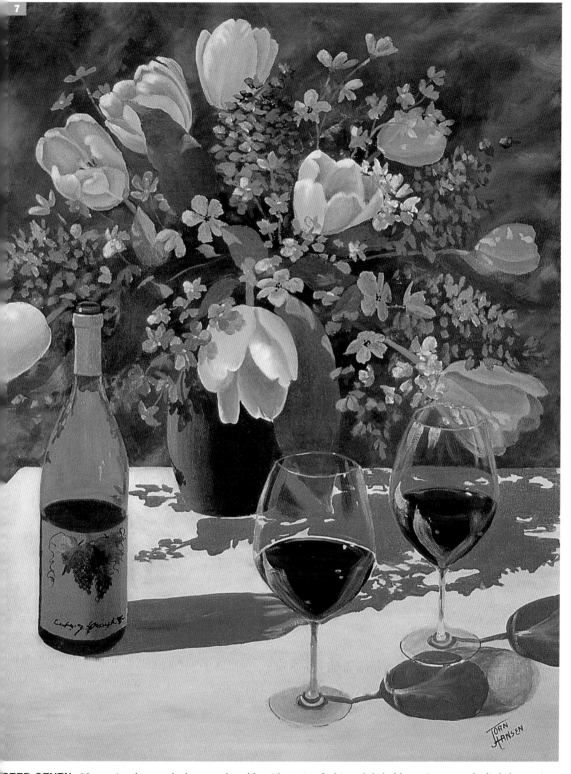

white + phthalo blue + crimson + a little burnt sienna + medium gray-blue

STEP SEVEN Now paint the cast shadows on the table with a mix of white, phthalo blue, crimson, and a little burnt sienna to gray it. Notice that the wine bottle's shadow contains some interesting pinks and greens because the color of the bottle and the wine is reflected onto the tabletop. Then step back and evaluate the painting. The foreground tulip was commanding too much attention, and it ended up almost in the dead center of the painting. Bring this flower into the composition by painting another lavender flower above it and adding some cast shadows from the lavender flowers. Finally define the table's shape on the left by creating the squared corner.

Conclusion

When you've completed an acrylic painting, you can frame it without giving it any further treatment.

But if you wish, you can protect your paintings with various types of acrylic varnishes, which are available in liquid or spray. (Do not use oil varnishes over your acrylic paintings.) The varnish seals the painting to maintain the original luster and brightness of the paint. Depending on your taste, you can select a varnish that gives the painting either a gloss or matte finish; a combination of the two will create a satin fin-

ish. For a smooth, flat finish without the obvious appearance of brushstrokes, thin your varnishes and apply them with horizontal brushstrokes. For a slightly textured look, apply the varnish in thicker layers, stroking in different directions. Although some varnishes may appear somewhat milky at first, they all eventually dry to a clear, transparent finish.

We hope the exercises in this book have been helpful for improving your acrylic painting skills. Use the techniques you've learned here, and apply them to your own compositions and designs. Soon you'll discover the many advantages of this exciting and versatile medium. Happy painting!

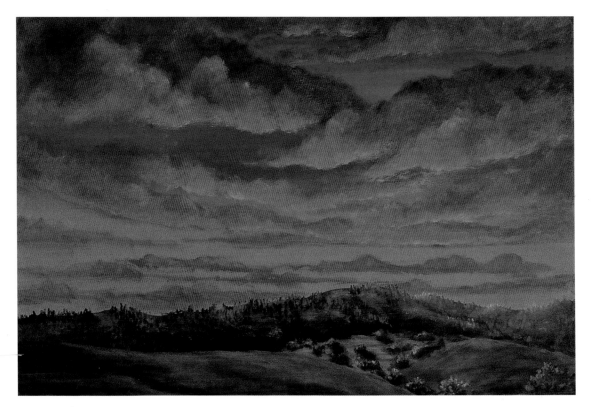